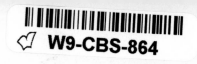

What The Road Passes By

Dewitt Jones

Dewitt Jones has been a photographer and filmmaker for the past twelve years. He studied at Dartmouth College and did his graduate work at UCLA in filmmaking. His film, *John Muir's High Sierra,* was nominated for two Academy awards.

Dewitt's photographs have been published in numerous articles in National Geographic Magazine. His first book, *John Muir's America* was chosen for inclusion in the White House Library.

When he is not on a lecture tour with his movies, or on photographic assignments, he lives in Bolinas, California with his wife, Babs, and his son, Brian.

Eleanor Huggins

Eleanor Huggins has been actively involved with environmental education and conservation. A graduate of Mount Holyoke College in Massachusetts, she has been editor of Loma Prietan, a Sierra Club newsletter. She wrote her first book, *Skiing the West* in 1967.

Eleanor has been active in the Sierra Club, Environmental Volunteers, and currently coordinates the educational programs for a regional park district in California.

She and Dewitt Jones collaborated for several years to prepare, *What The Road Passes By.* Eleanor and her husband, Bob, reside in Stanford, California.

What The Road Passes By

Photographs by Dewitt Jones
Edited by Eleanor Huggins

Graphic Arts Center Publishing Co.
Portland, Oregon

International Standard Book Number 0-912856-47-5
Library of Congress Catalog Number 79-84035
Copyright © 1978 by Dewitt Jones
Graphic Arts Center Publishing Co.
2000 N.W. Wilson,
Portland, Oregon 97209
503/224-7777
Designer: Jon Goodchild
Printer: Graphic Arts Center
Binding: Lincoln & Allen
Printed in the United States of America

1st printing 1978
Revised edition 1979

We wish to thank David Burton for letting us quote him.

We also wish to thank the following authors and publishers for permission to reprint selections from copyrighted works:

From *The Magic World, American Indian Songs & Poems,* selected and edited by William Brandon. Copyright © 1971 by William Brandon. Reprinted by permission of William Morrow & Co., Inc.

From *Pilgrim at Tinker's Creek,* by Annie Dillard. Copyright © 1974 by Anne Dillard. Reprinted by permission of Harper & Row, Publishers, Inc.

From *The Gentle Art of Tramping,* by Stephen Graham. Copyright © 1926 D. Appleton & Co.

From *Gift From The Sea,* by Anne Morrow Lindbergh. Copyright © 1955 by Anne Morrow Lindbergh. Reprinted by permission of Pantheon Books, a division of Random House, Inc.

From *Runes Of The North,* by Sigurd F. Olson. Copyright © 1963 by Sigurd F. Olson. Reprinted by permission of Alfred A. Knopf.

From *Reflections From The North Country* by Sigurd F. Olson, Copyright © 1976 by Sigurd F. Olson. Reprinted by permission of Alfred A. Knopf.

From *Markings,* by Dag Hammarskjöld, translated by Leif Sjöberg and W.H. Auden. Copyright © 1964 Alfred A. Knopf, Inc. and Faber and Faber Ltd. Reprinted by permission of the publisher.

From *A Sand County Almanac, With Other Essays On Conservation* from *Round River* by Aldo Leopold. Copyright © 1977 by Oxford University Press, Inc. Reprinted by permission.

"Desert Places" from *The Poetry Of Robert Frost* edited by Edward Connery Lathem. Copyright © 1936 by Robert Frost. Copyright © 1964 by Lesley Frost Ballantine. Copyright © 1969 by Holt, Rinehart and Winston. Reprinted by permission of Holt, Rinehart and Winston Publishers.

Quotes by John Muir from *John Of The Mountains* by Linnie Marsh Wolfe, 1938. Copyright renewed 1966 by John Muir Hanna and Ralph Eugene Wolfe. Courtesy of Houghton Mifflin Company.

From *Listening Point,* by Sigurd F. Olson, Copyright © 1958 by Sigurd F. Olson. Reprinted by permission of Alfred A. Knopf.

From *the Immense Journey,* by Loren Eiseley. Copyright © 1957 by Loren Eiseley. Reprinted by permission of Random House, Inc.

"Bare Tree" by Anne Morrow Lindbergh. Copyright © 1955 by Anne Morrow Lindbergh. Reprinted from *Unicorn and Other Poems* by Anne Morrow Lindbergh. Reprinted by permission of Pantheon Books, a division of Random House, Inc.

From "Return," by Robinson Jeffers. Copyright © 1935, renewed 1963 by Donnan Jeffers and Garth Jeffers. Reprinted from *Selected Poetry Of Robinson Jeffers,* by permission of Random House, Inc.

From *On The Loose,* by Terry and Renny Russell, Sierra Club, 1969. Reprinted by permission of the publisher.

There are times in my life, sometimes with a camera, sometimes without, when the world is so achingly beautiful, when everything holds such meaning, that I am incapable of any expression except tears of joy. The boundaries of my being begin to blur, whatever separates one thing from another begins to dissolve, and in that confluence of light and line and law, lies an experience for which I have no words.

This experience is the exception not the rule, yet it happens often enough that I no longer believe it to be just coincidence, but rather a level of reality that is always there if I am open enough to see it. This level of being is incredibly positive. It doesn't negate the pain and suffering of the world, but puts it into a larger context and allows me to experience this context directly, not just with my intellect, but with my entire being.

The book is an attempt to describe this experience and the consequences it has on one's life. The quotes are touchstones, runes. Some I have experienced, others are still faint calls from a life I may one day come to know. But though I can't yet live them, I know they are true. They are all words to the same song. A song that sings of an ever unfolding miracle. A song of wonder; a song of joy; a song of life.

Dewitt Jones

"Night is drawing nigh—" How long the road is.
But, for all the time the journey has already
taken, how you have needed every second of it
in order to learn what the road passes—by.

Dag Hammarskjöld

Snow falling and night falling fast, oh, fast
In a field I looked into going past,
And the ground almost covered smooth in snow,
But a few weeds and stubble showing last.

The woods around it have it—it is theirs.
All animals are smothered in their lairs.
I am too absent-spirited to count;
The loneliness includes me unawares.

And lonely as it is, that loneliness
Will be more lonely ere it will be less—
A blanker whiteness of benighted snow
With no expression, nothing to express.

They cannot scare me with their empty spaces
Between stars—on stars where no human race is.
I have it in me so much nearer home
To scare myself with my own desert places.

Robert Frost

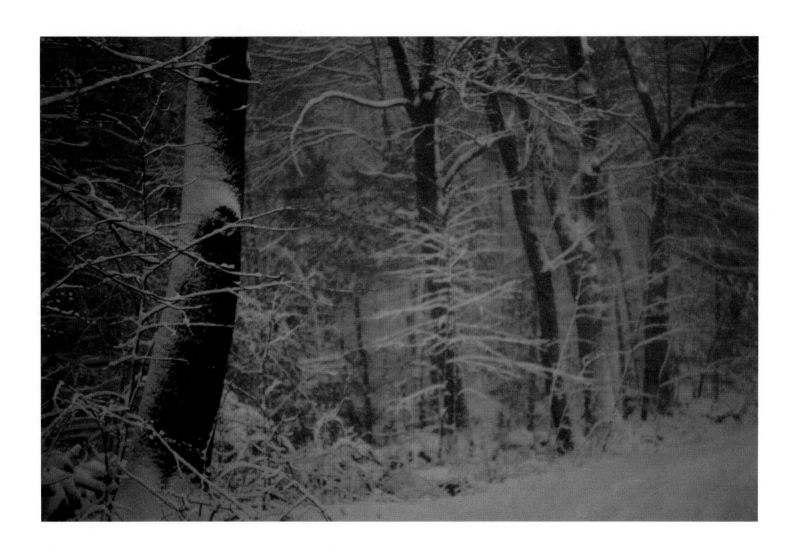

So rests the sky against the earth. The dark still
tarn in the lap of the forest. As a husband embraces
his wife's body in faithful tenderness, so the bare
ground and trees are embraced by the still, high,
light of the morning.

I feel an ache of longing to share in this embrace
to be united and absorbed. A longing like carnal
desire, but directed towards earth, water, sky and
returned by the whispers of the trees, the fragrance
of the soil, the caresses of the wind, the embrace of
water and light. Content? No, no, no—but refreshed,
rested—while waiting.

Dag Hammarskjöld

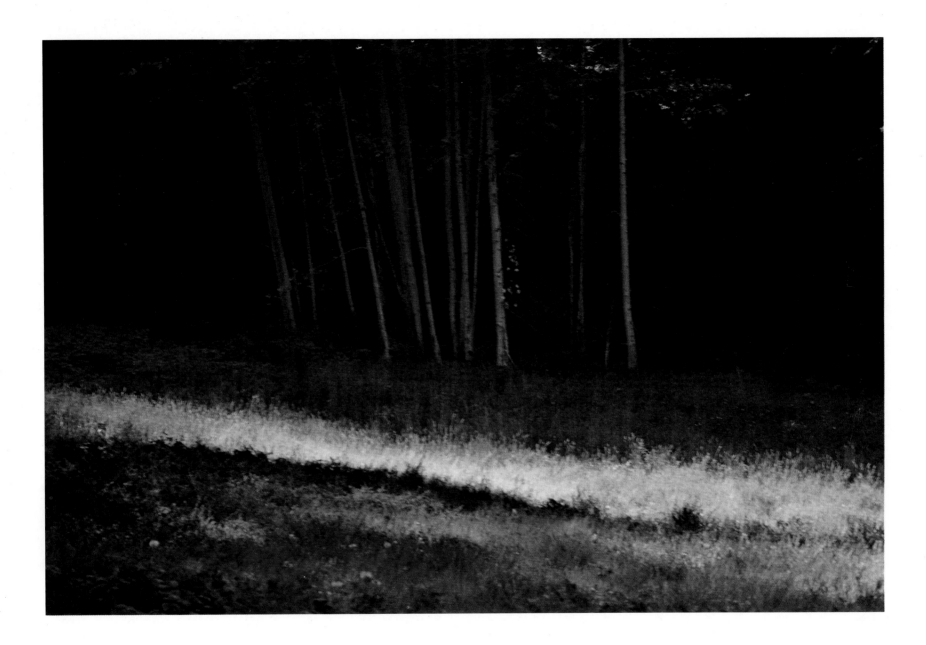

I am being driven forward
Into an unknown land

Dag Hammarskjöld

'That one might be translated into light and song.'
To let go the image which, in the eyes of this
world, bears your name, the image fashioned in
your consciousness by social ambition and sheer
force of will. To let go

Dag Hammarskjöld

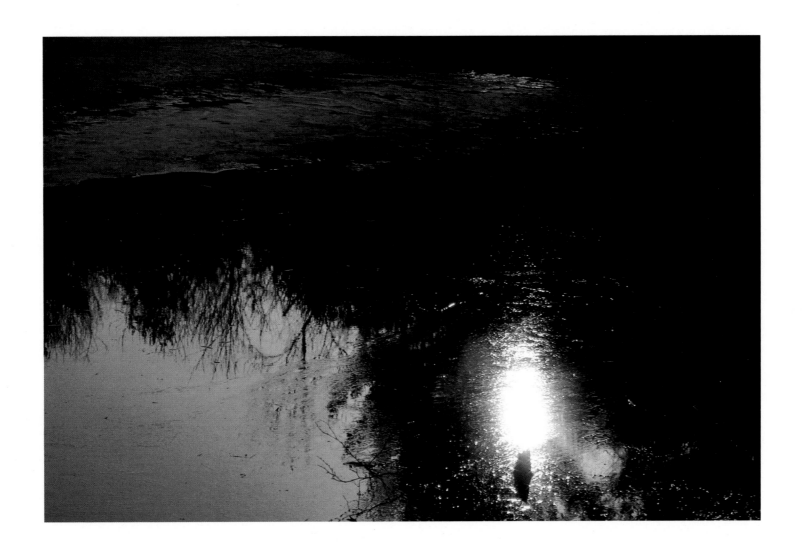

. . . lie empty, open, choiceless as a beach —
waiting for a gift from the sea.

Anne Morrow Lindbergh

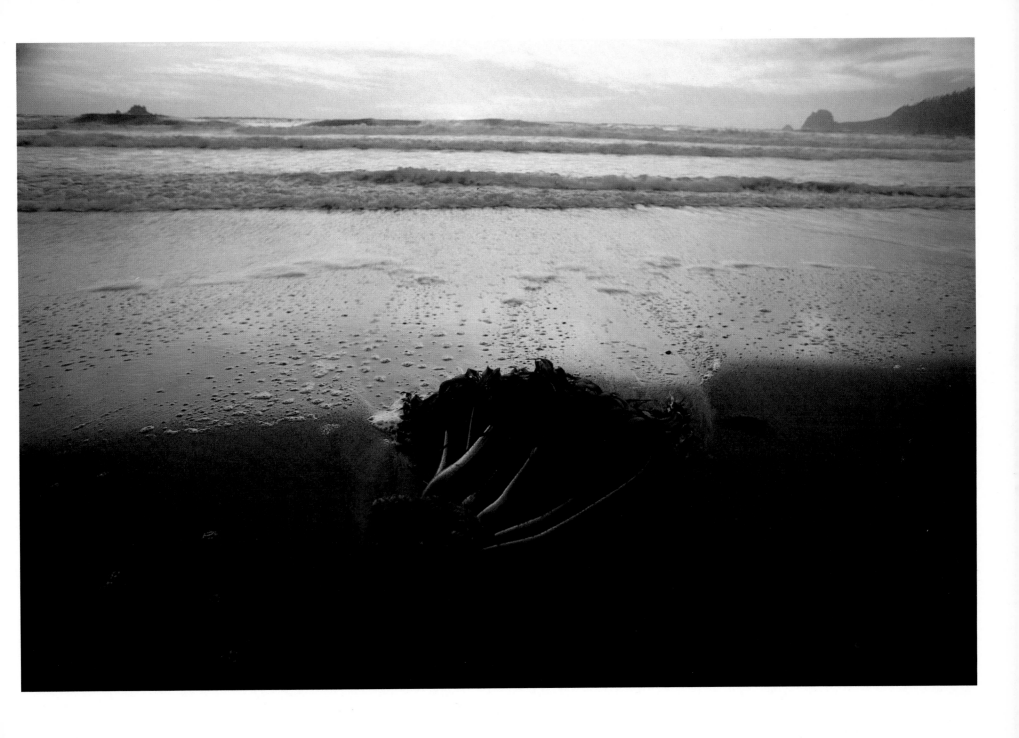

...as you sit on the hillside, or lie
prone under the trees of the forest, or
sprawl wet-legged on the shingly beach of
a mountain stream, the great door, that does
not look like a door, opens.

Stephen Graham

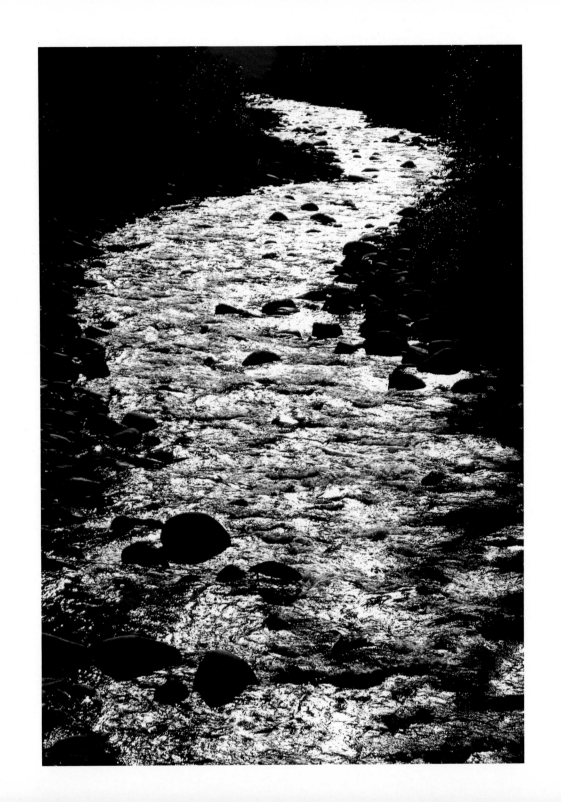

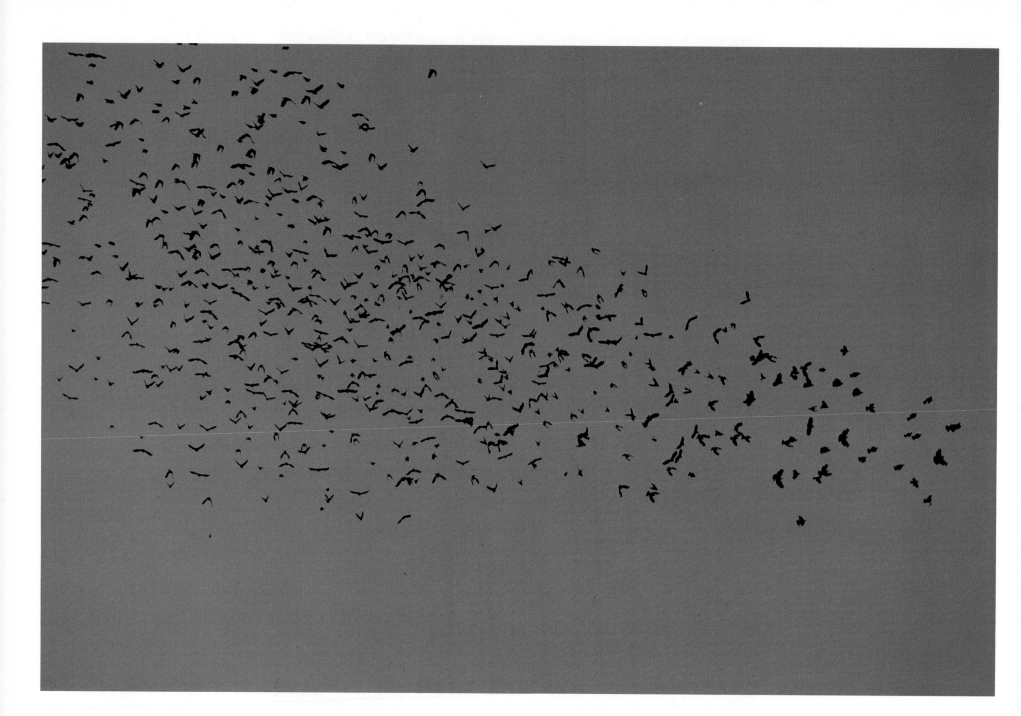

My mind moves from its captivity toward a freedom I've yet to understand.

David Burton

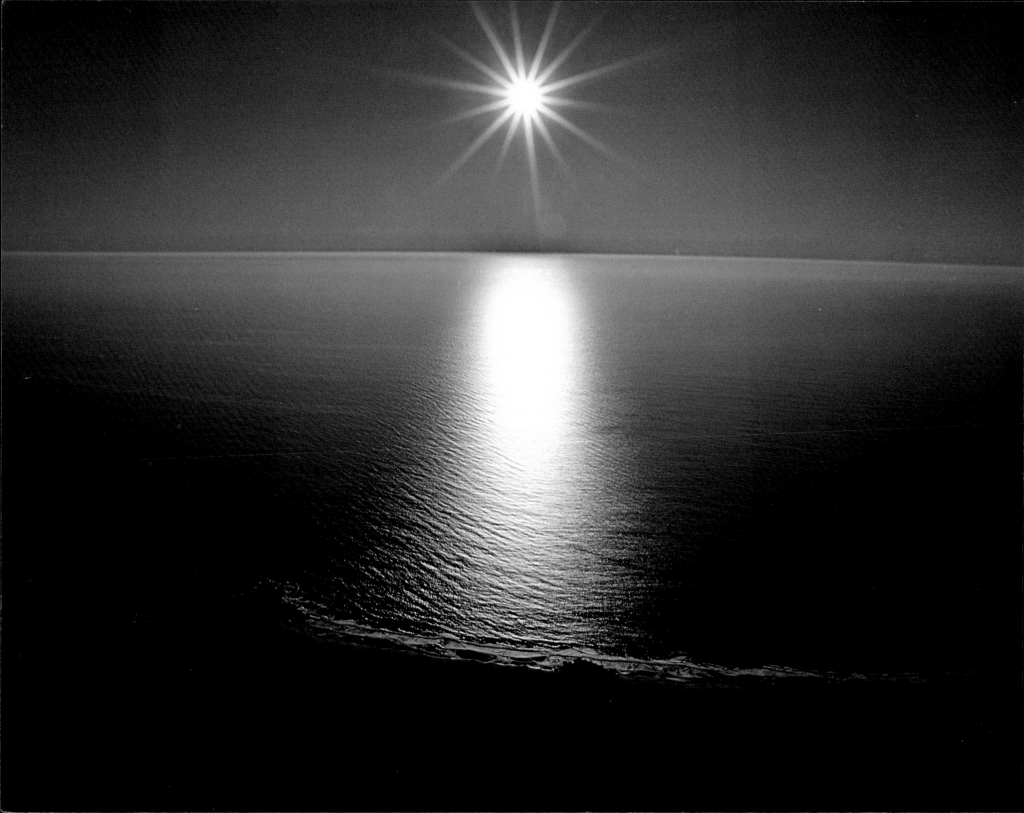

The waves echo behind me. Patience—Faith—Openness,
is what the sea has to teach. Simplicity—Solitude—
Intermittency . . . But there are other beaches to
explore. There are more shells to find. This is
only a beginning.

Anne Morrow Lindbergh

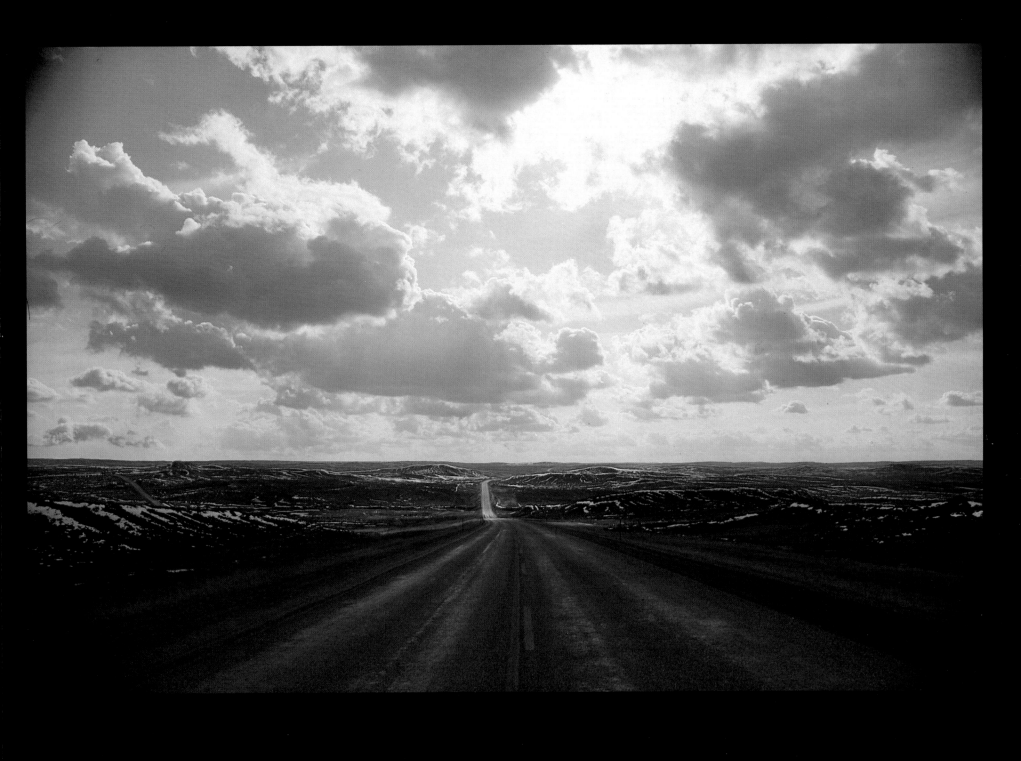

On a fair morning the mountain invited you to get
down and roll in its new grass and flowers . . .
Every living thing sang, chirped, and burgeoned.
Massive pines and firs, storm-tossed these many
months, soaked up the sun in towering dignity.
Tassel-eared squirrels, poker-faced but exuding
emotion with voice and tail, told you insistently
what you already knew full well: that never had
there been so rare a day, or so rich a solitude
to spend it in.

Aldo Leopold

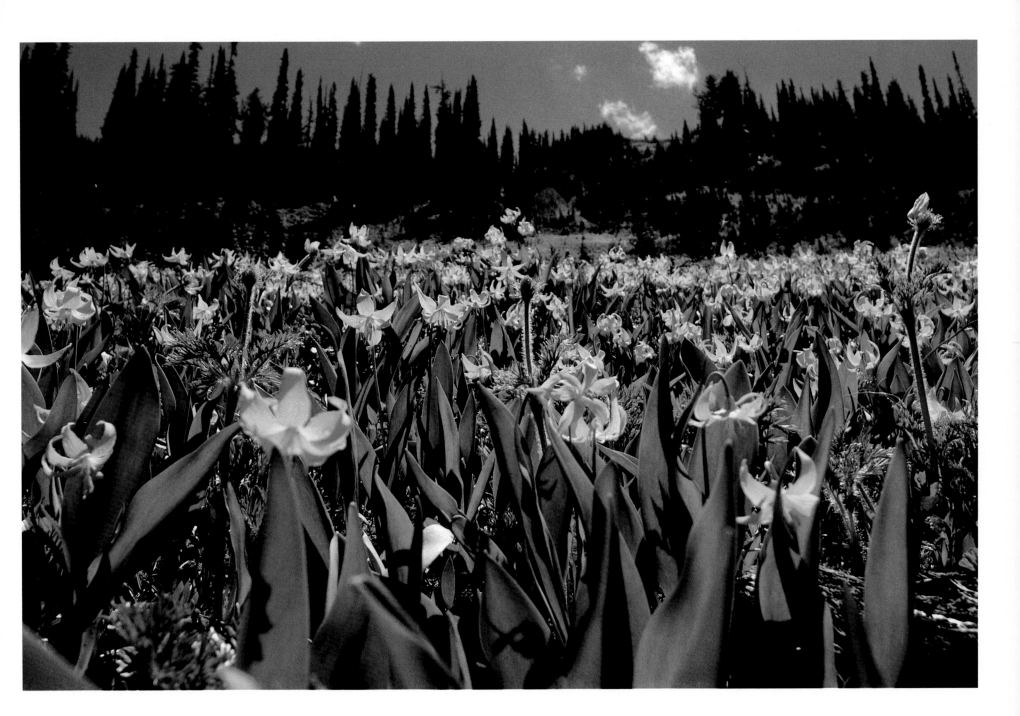

If the day and night are such that you greet them
with joy, and life emits a fragrance like flowers and
sweet-scented herbs, is more elastic, more starry,
more immortal, — that is your success. All nature
is your congratulation, and you have cause momentarily
to bless yourself.

Henry David Thoreau

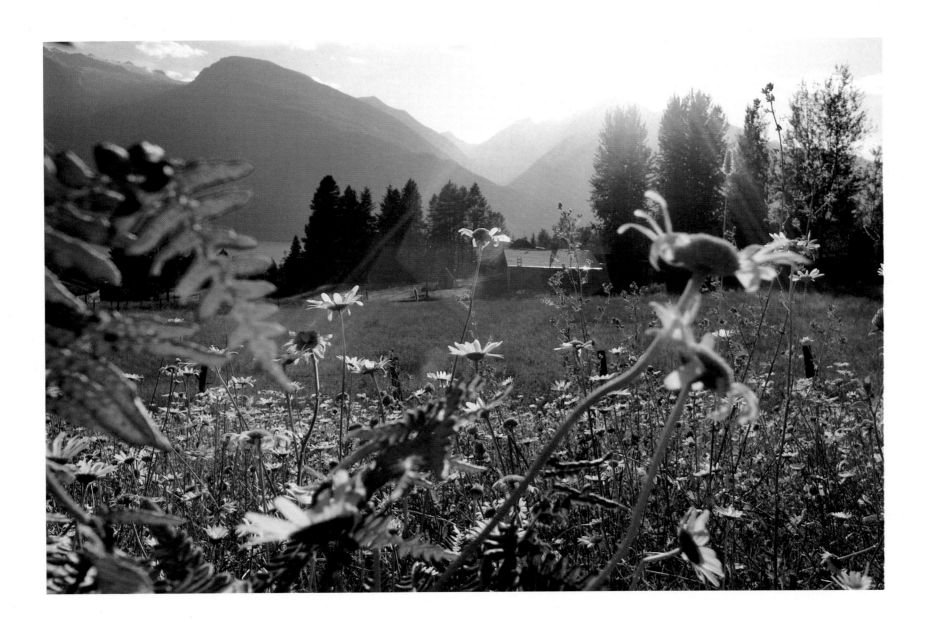

My runes have come from the wilderness,
for in its solitude, silence, and freedom,
I see more clearly those values and influences
that over the long centuries have molded us
as a race. I know there are moments of insight
when ancient truths do stand out more vividly,
and one senses anew his relationship to the
earth and to all life. Such moments are worth
waiting for, and when they come in some
unheralded instant of knowing, they are of
the purest gold.

Sigurd Olson

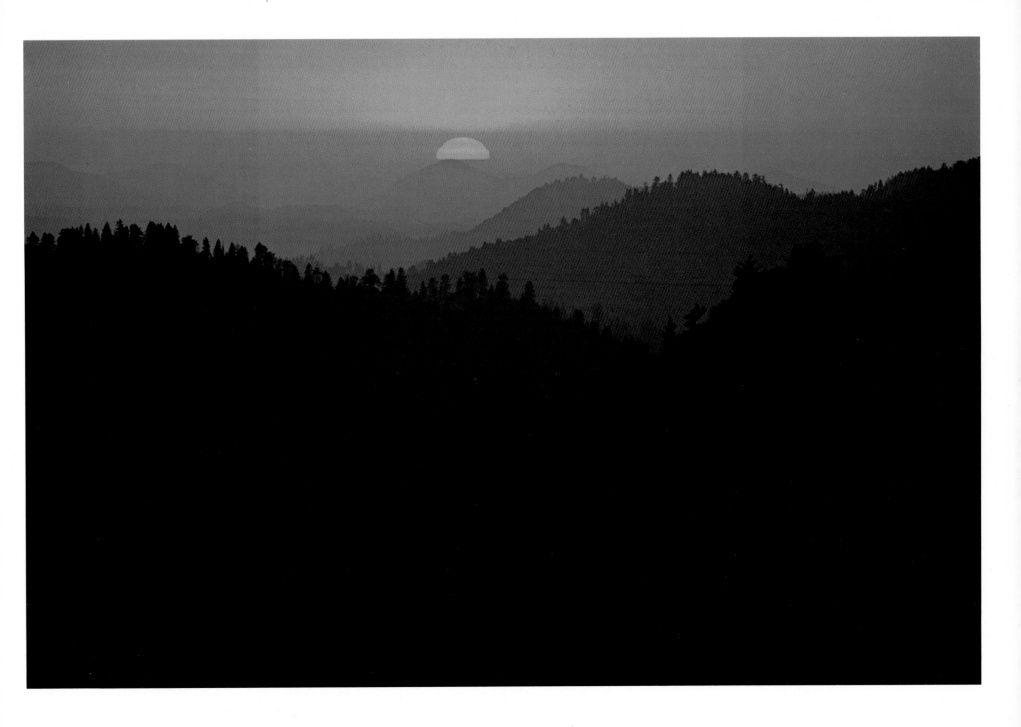

. . .such is the irresistible nature of truth
that all it asks, and all it wants,
is the liberty of appearing.

Thomas Paine

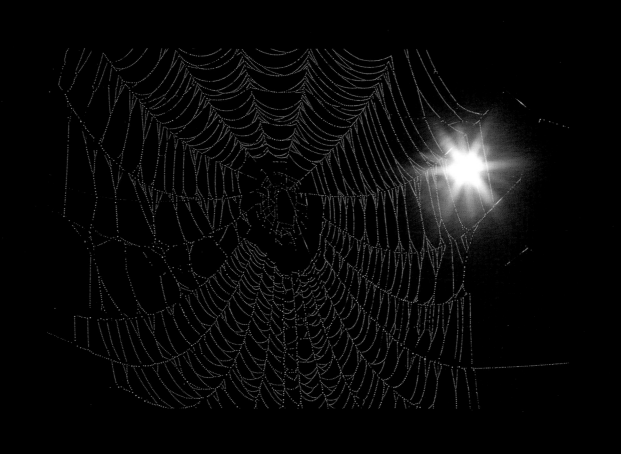

God secure me from security, now and forever, Amen.

Who's afraid of the universe?
It's midnight on the desert or the coast or high
above timberline, the Milky Way is close and
the stars are singing.
I am not small, I fill the sphere.
I tremble before the cosmos no more than a
fish trembles before the tides.

Terry and Renny Russell

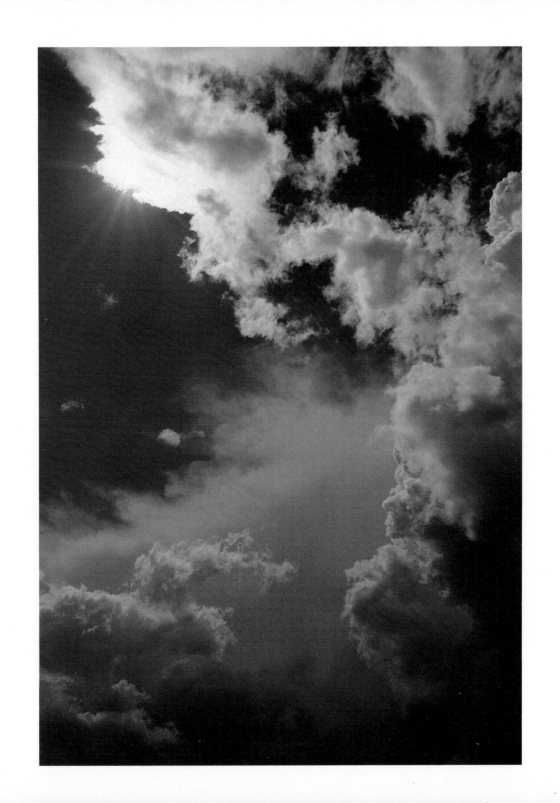

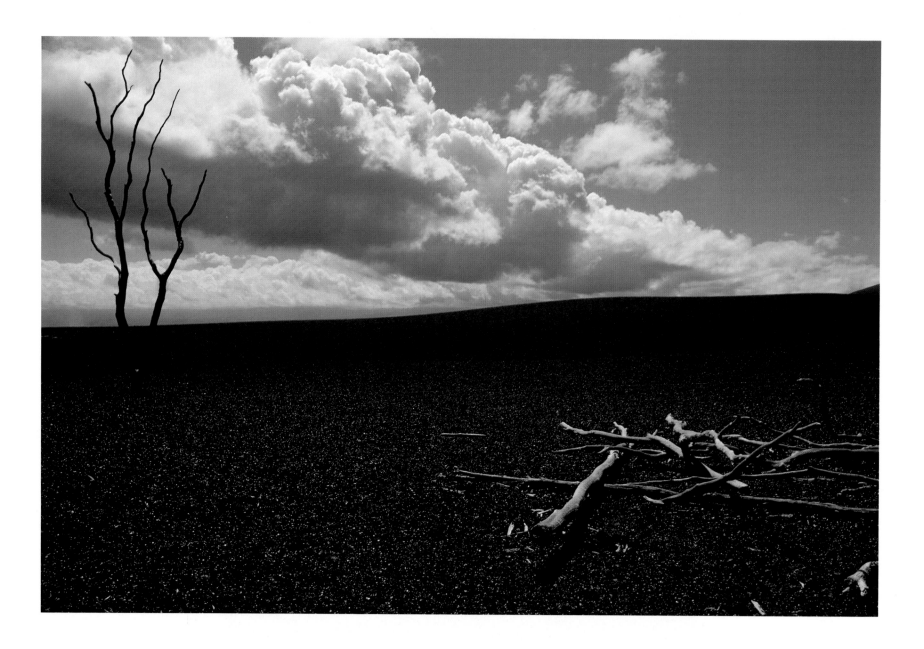

Never let success hide its emptiness from you,
achievement its nothingness, toil its desolation.
And so keep alive the incentive to push on further,
that pain in the soul which drives us beyond ourselves.

Whither? That I don't know. That I don't ask to know.

Dag Hammarskjöld

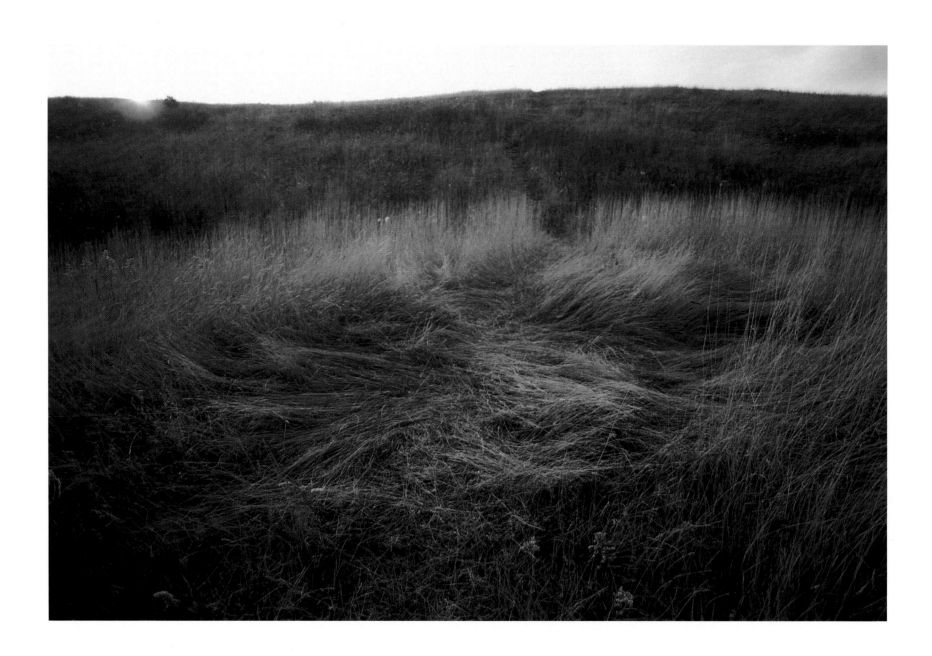

Our life is a faint tracing
on the surface of mystery

Annie Dillard

I walk out; I see something, some event that
would otherwise have been utterly missed and
lost; or something sees me, some enormous
power brushes me with its clean wing,
and I resound like a beaten bell.

Annie Dillard

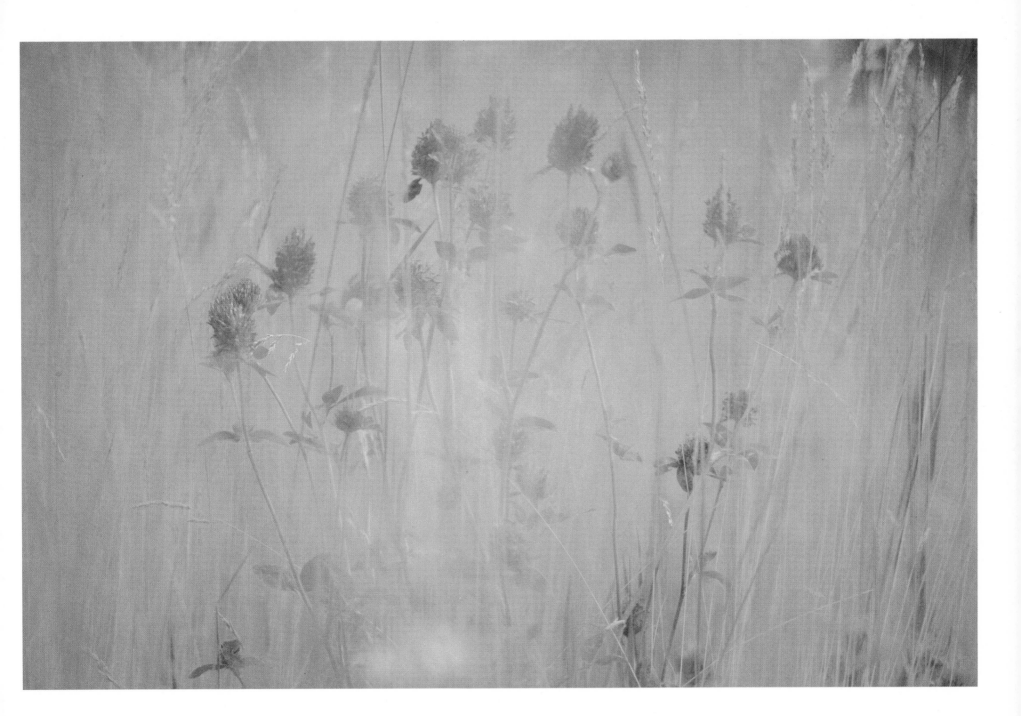

If only I may grow: Firmer, simpler—quieter, warmer.

Dag Hammarskjöld

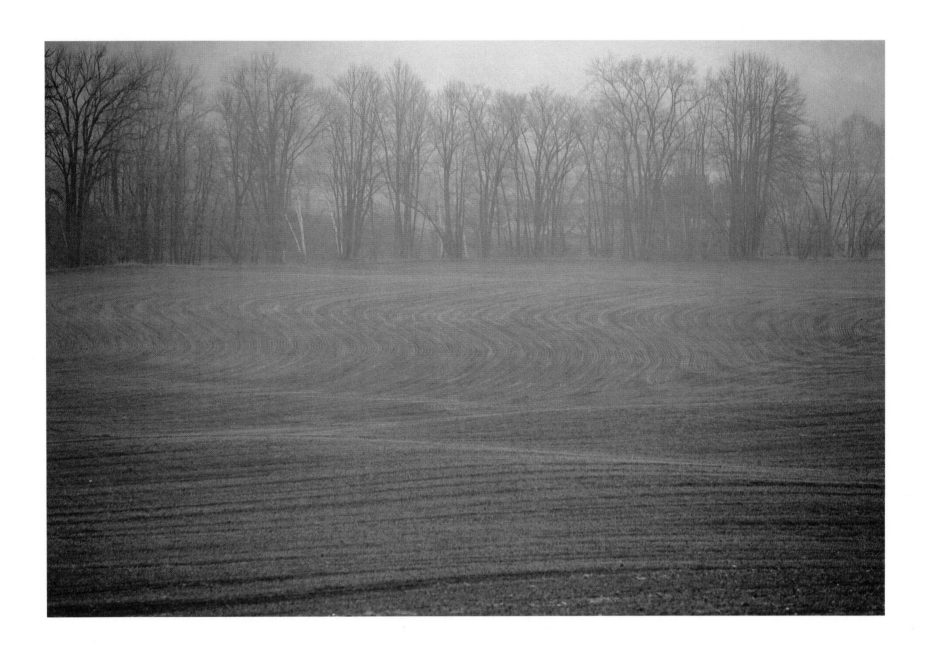

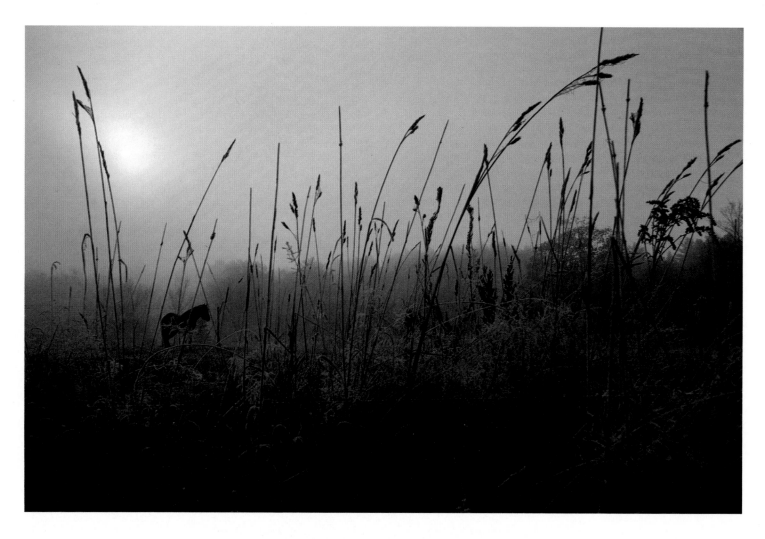

Perhaps the facts most astounding and most real
are never communicated man to man.

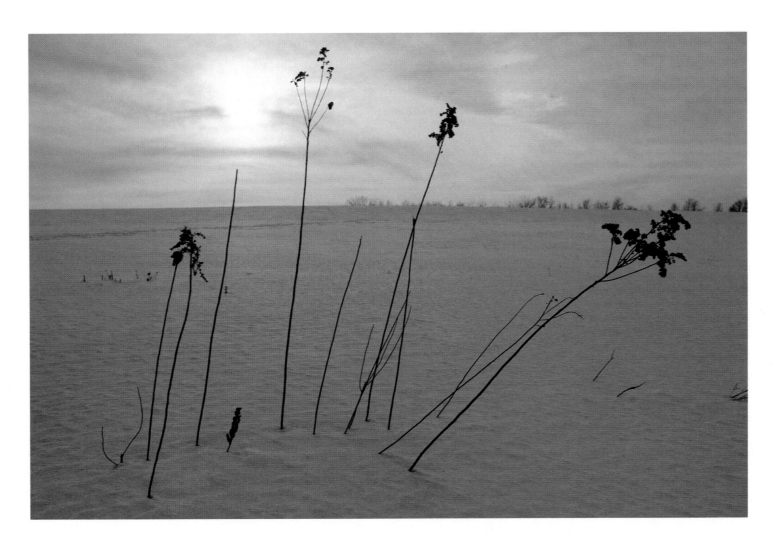

The true harvest of my daily life is somewhat as intangible
and indescribable as the tints of morning and evening.

Henry David Thoureau

The light died in the low clouds. Falling snow
drank in the dusk. Shrouded in silence, the
branches wrapped me in their peace. When the
boundaries were erased, once again the wonder:
that *I* exist.

Dag Hammarskjöld

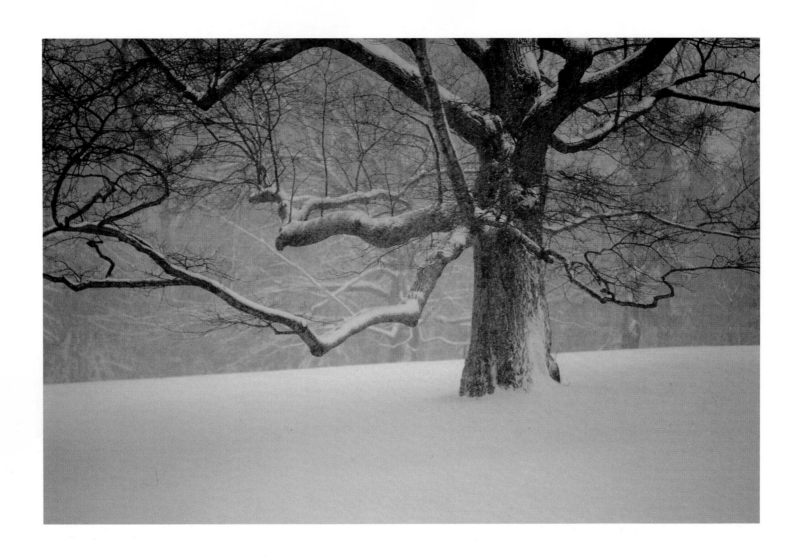

The most beautiful thing we can experience
is the mysterious. It is the fundamental emotion
which stands at the cradle of true art and true science.

To know that what is impenetrable to us
really exists, . . .

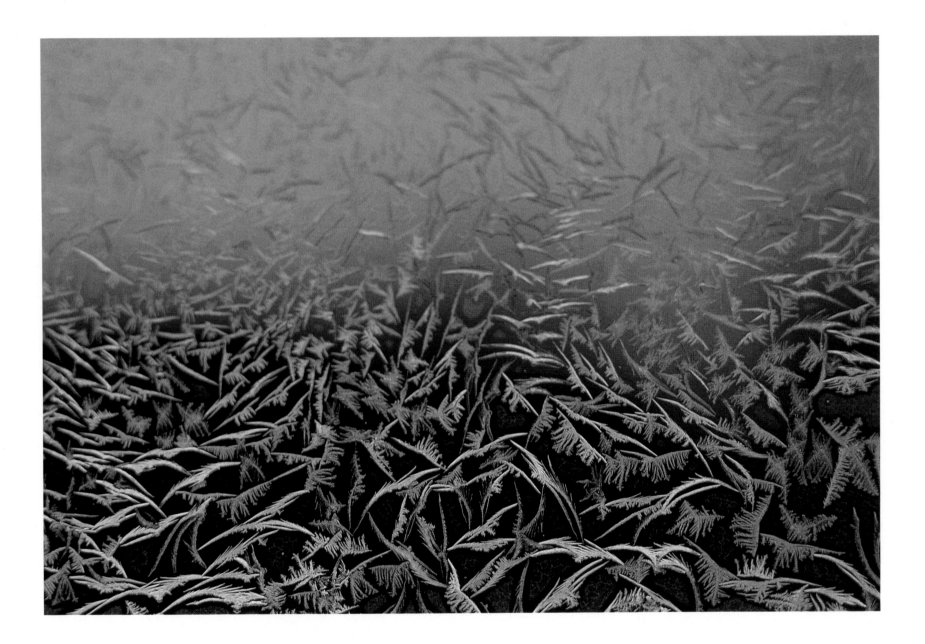

manifesting itself as the highest wisdom
and the most radiant beauty.

Albert Einstein

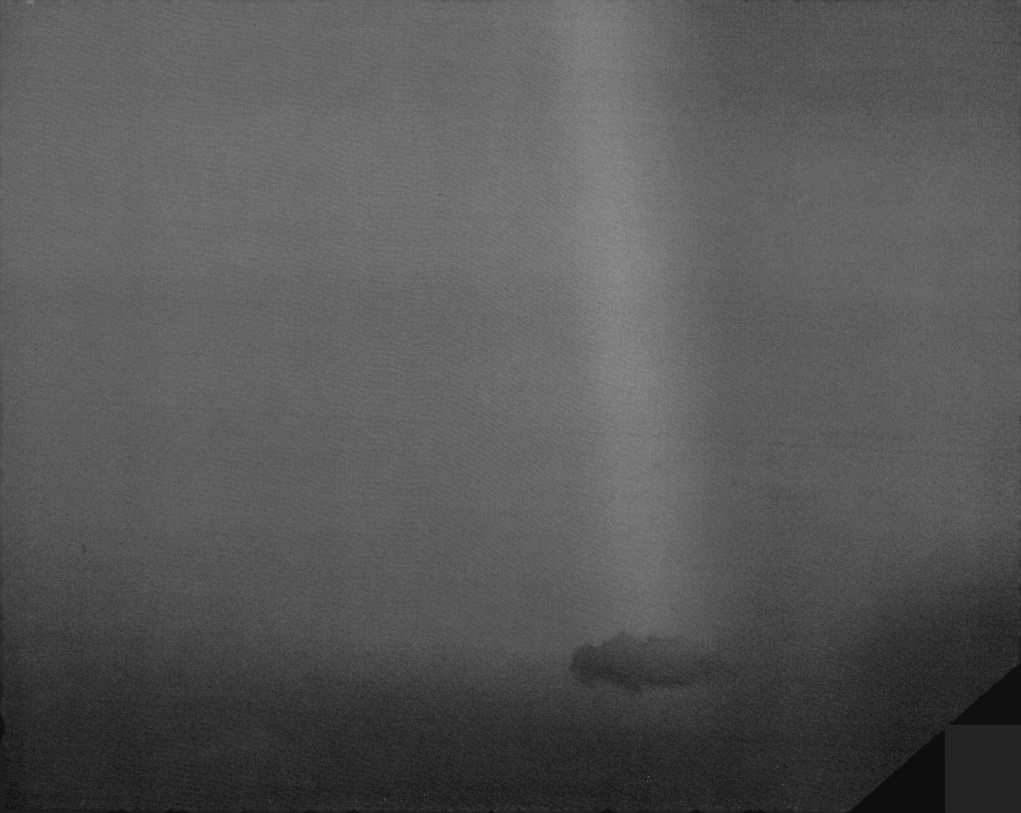

Once in a lifetime, perhaps, one escapes the actual confines of the flesh. Once in a lifetime, if one is lucky, one so merges with sunlight and air and running water that whole eons, the eons mountains and deserts know, might pass in a single afternoon

Loren Eiseley

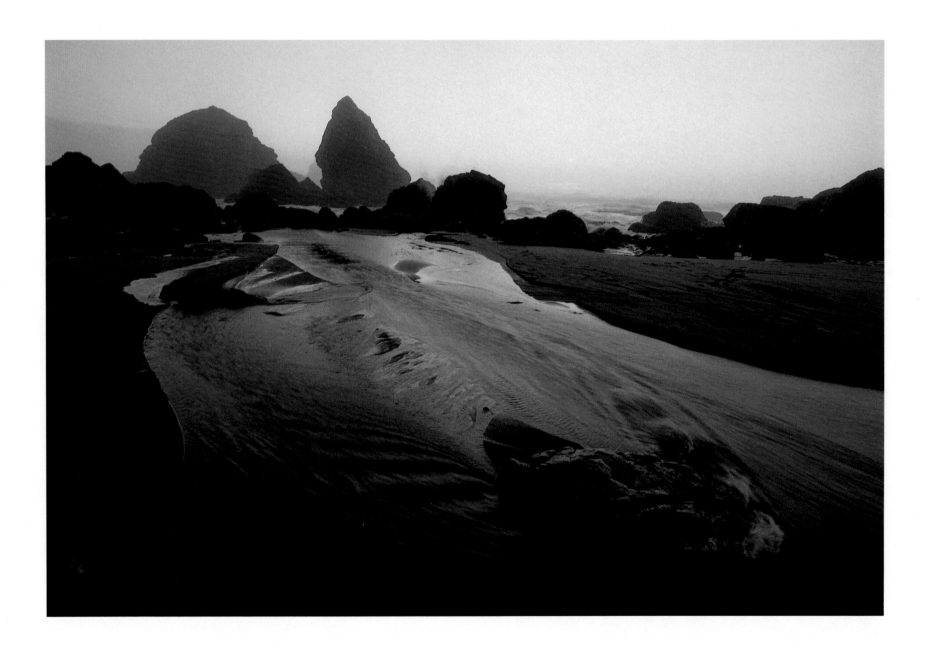

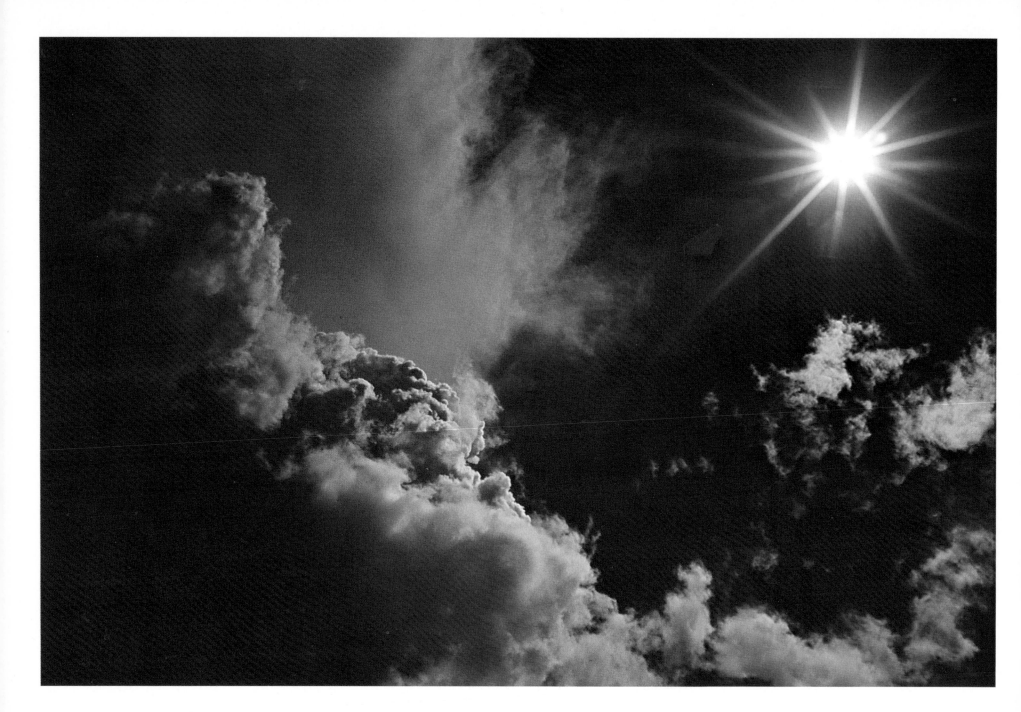

...I have seen the immensity of space and
glimpsed at times the grandeur of creation...
I have sensed the span of uncounted centuries...

and looked down the path all life has come.

Sigurd Olson

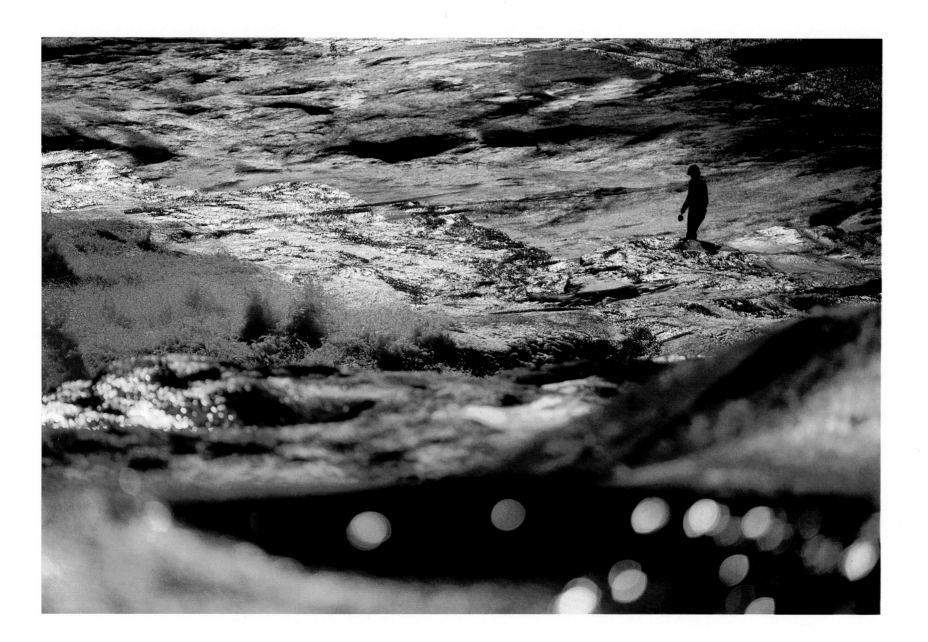

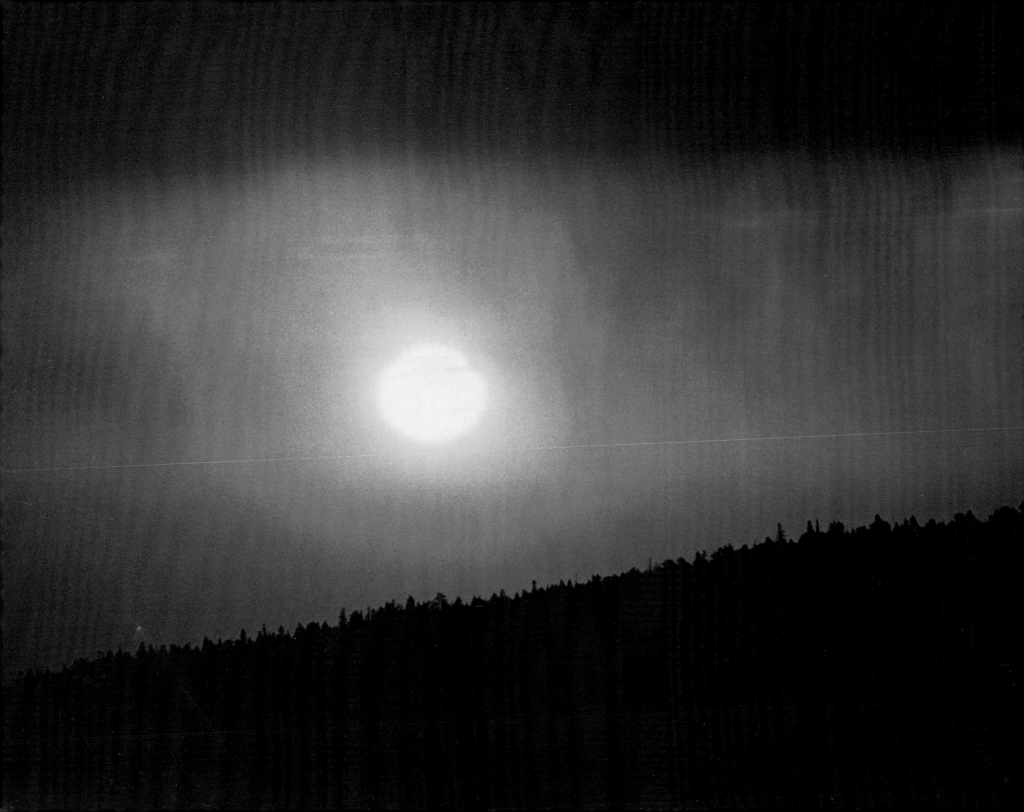

The divine spark is within us all
and when we are conscious of it,
we touch the eternal . . .

Sigurd Olson

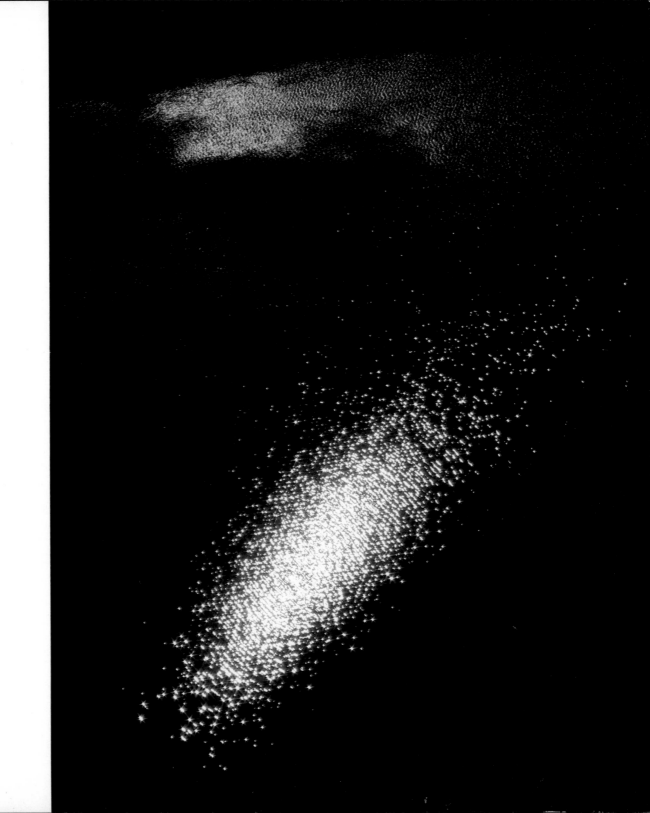

It was not like taking the veil,
no solemn abjuration of the world,
I only went out for a walk and finally
concluded to stay till sundown
for going out I found that I was
really going in.

John Muir

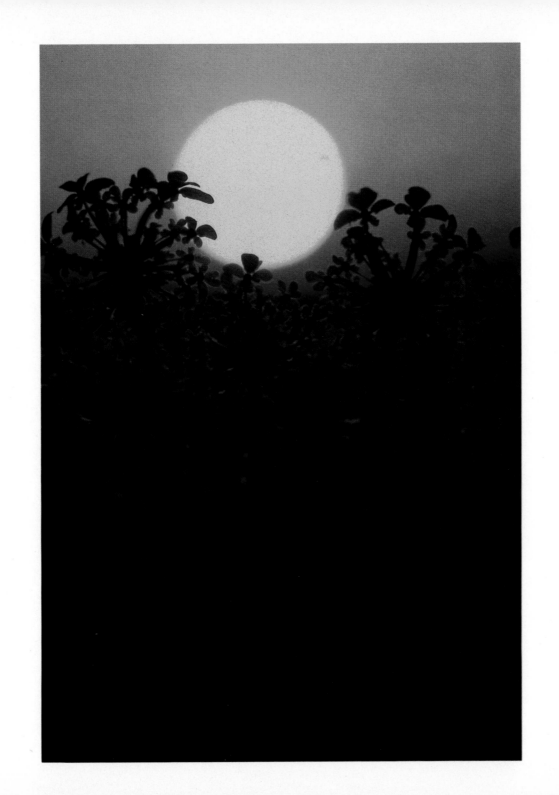

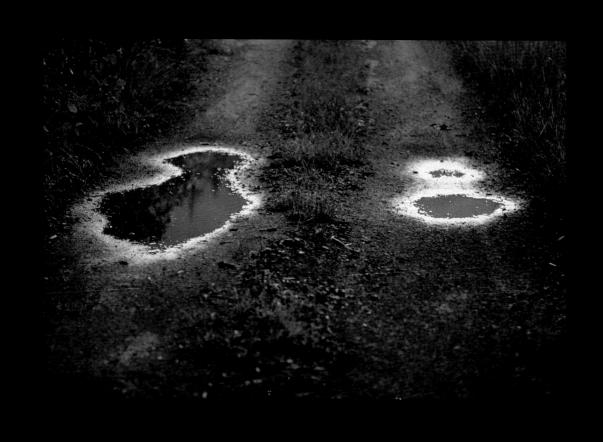

"Night is drawing nigh —" How long the road is.
But, for all the time the journey has already
taken, how you have needed every second of it
in order to learn what the road passes — by.

Dag Hammarskjöld

It is time for us to kiss the earth again,
It is time to let the leaves rain from the skies,
Let the rich life run to the roots again.

Robinson Jeffers

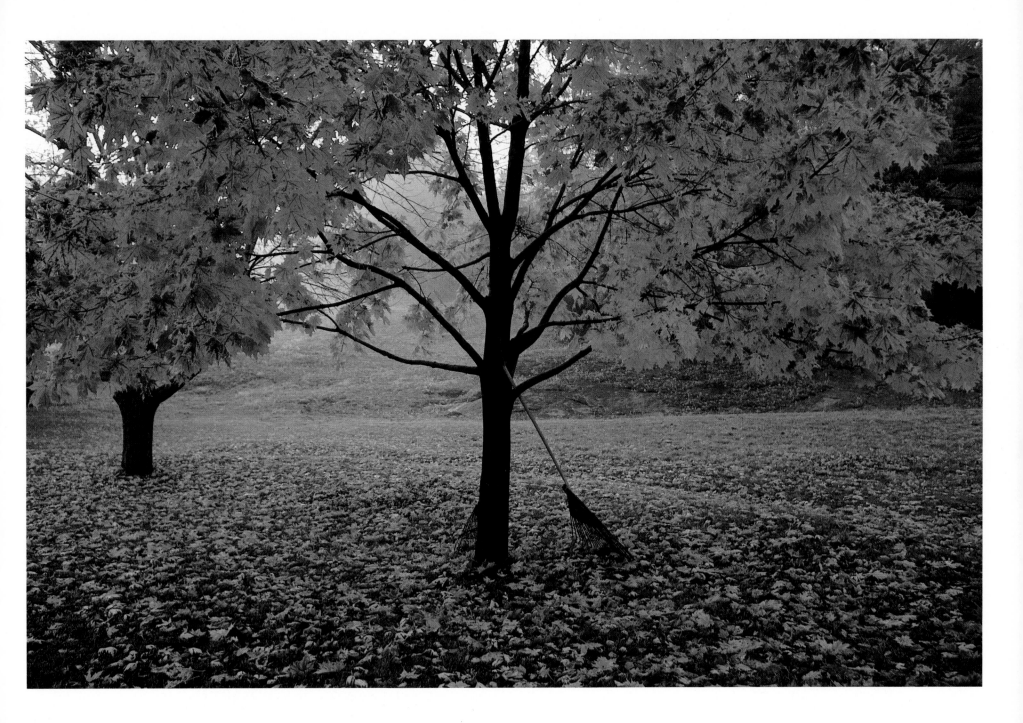

Already I have shed the leaves of youth,
Stripped by the wind of time down to the truth
Of winter branches. Linear and alone
I stand, a lens for lives beyond my own,
A frame through which another's fire may glow,
A harp on which another's passions, blow.

The pattern of my boughs, an open chart
Spread on the sky, to others may impart
Its leafless mysteries that once I prized,
Before bare roots and branches equalized;
Tendrils that tap the rain or twigs the sun
Are all the same; shadow and substance one.
Now that my vulnerable leaves are cast aside,
There's nothing left to shield, nothing to hide.

Blow through me, Life, pared down at last to bone,
So fragile and so fearless have I grown!

Anne Morrow Lindbergh

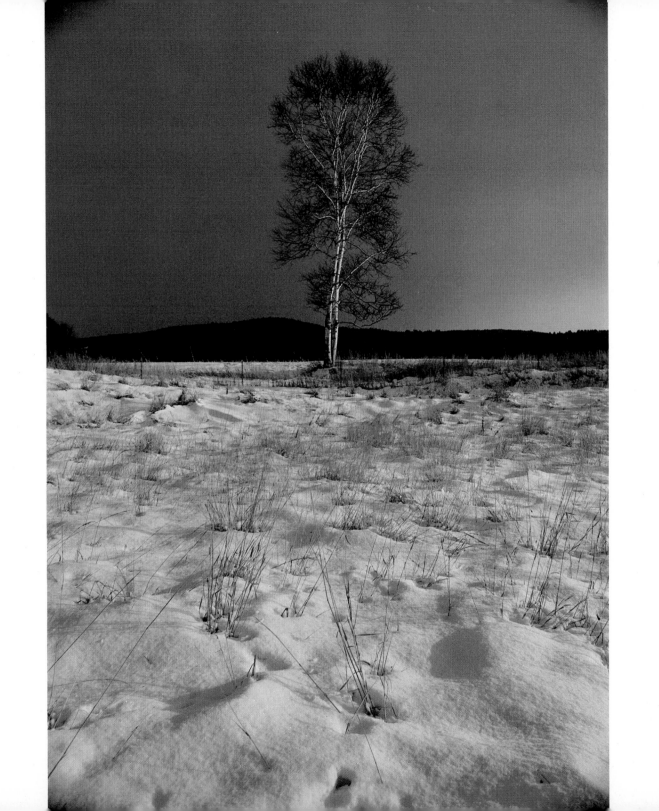

To be free, to be able to stand up and leave *everything* behind — without looking back. To say *Yes* —.

Dag Hammarskjöld

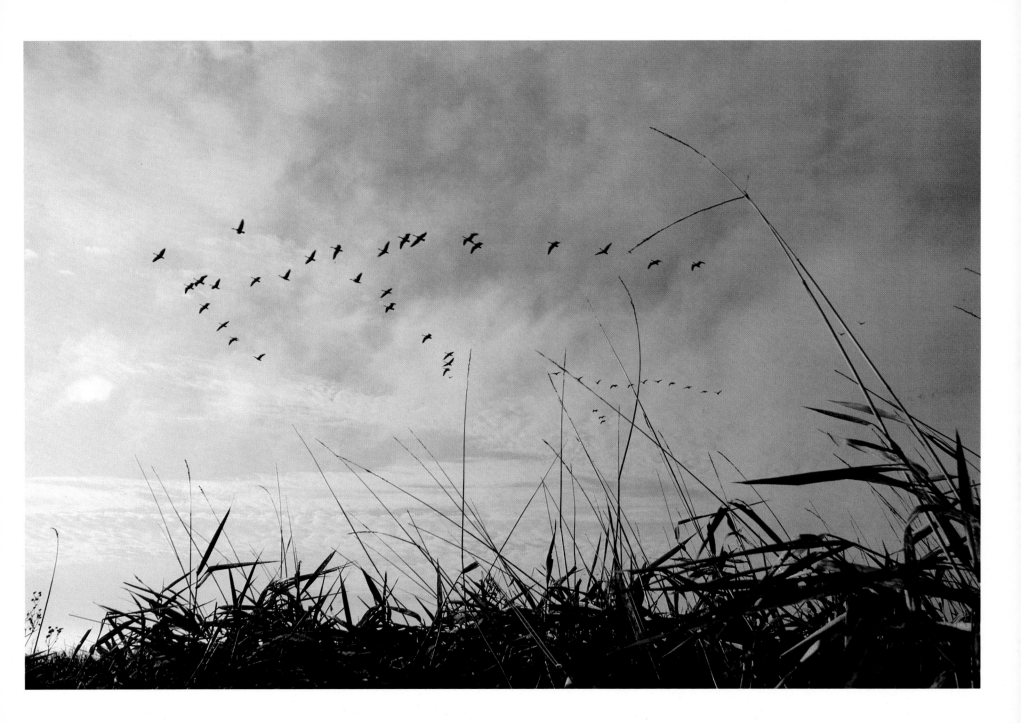

...I have discovered that I also live in "creation's dawn". The morning stars still sing together, and the world, not yet half made, becomes more beautiful everyday.

John Muir

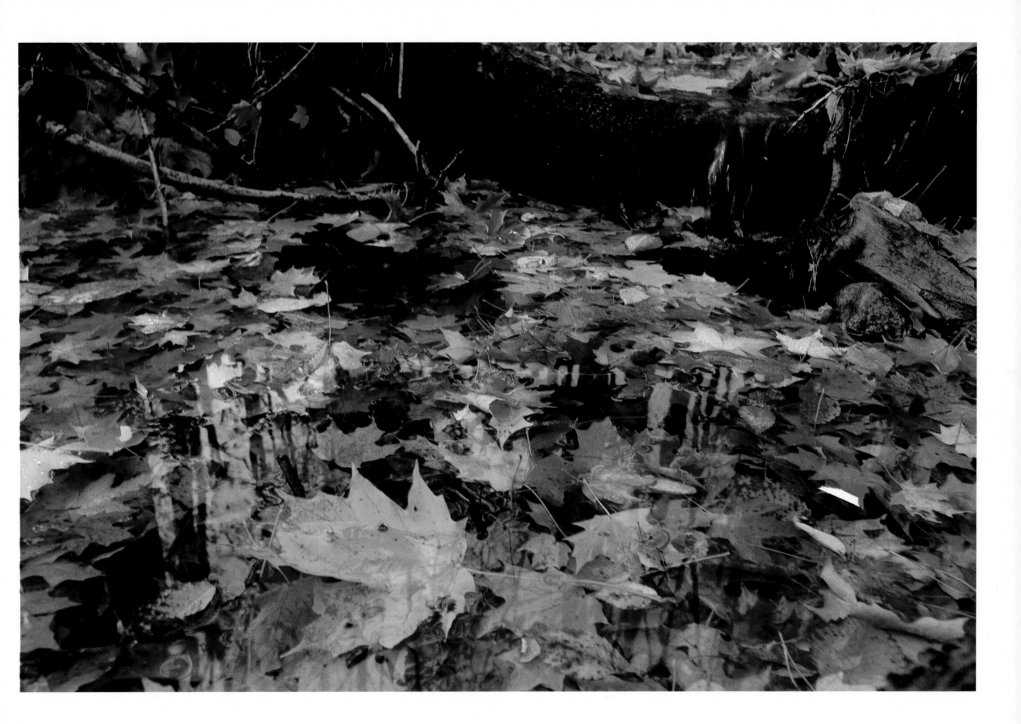

I walk in beauty.

Navajo Prayer

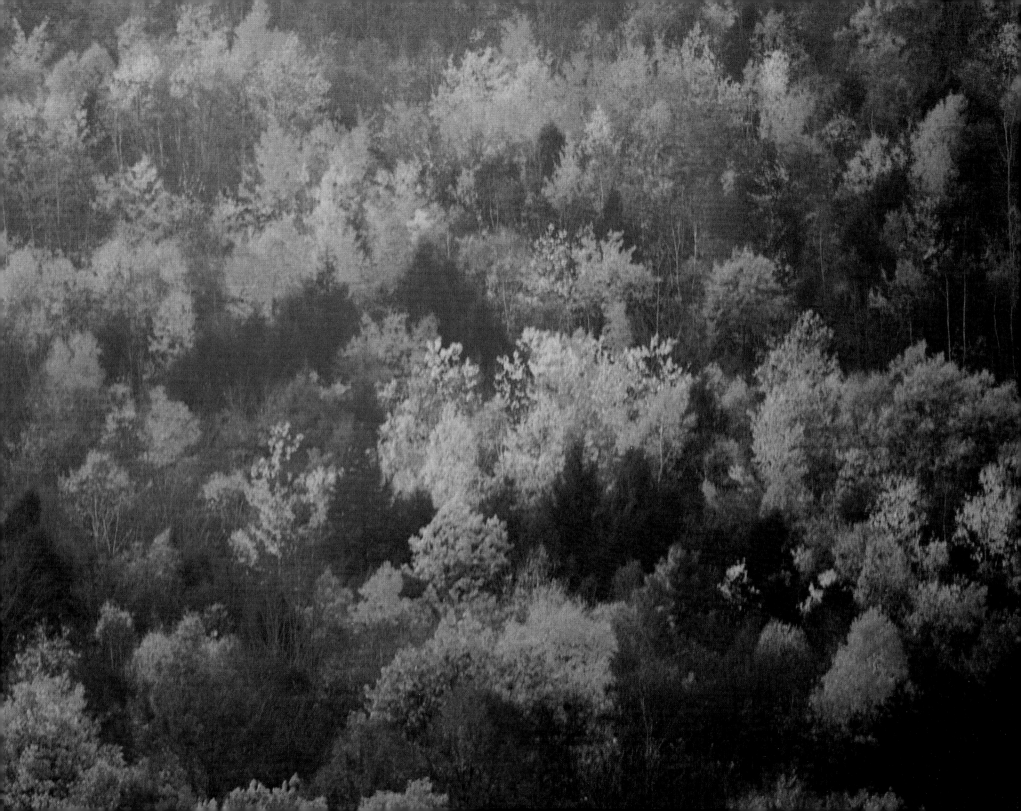

'Night is drawing nigh' —
For all that has been — Thanks!
To all that shall be — Yes!

Dag Hammarskjöld

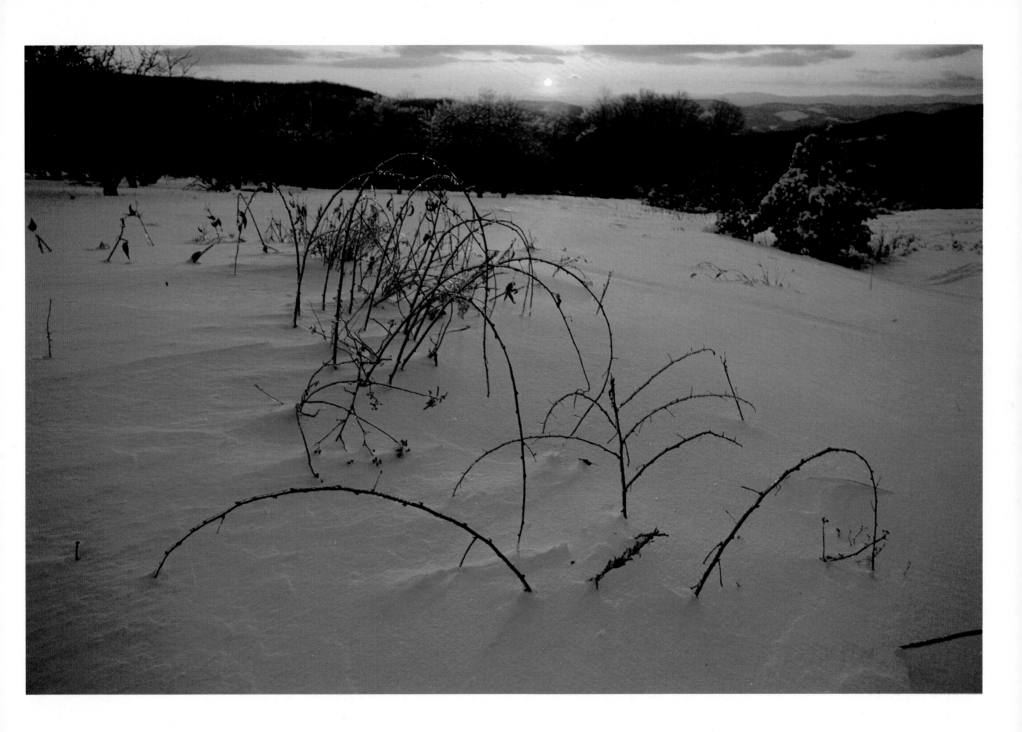

I, the song,
I walk here.

Indian Poem

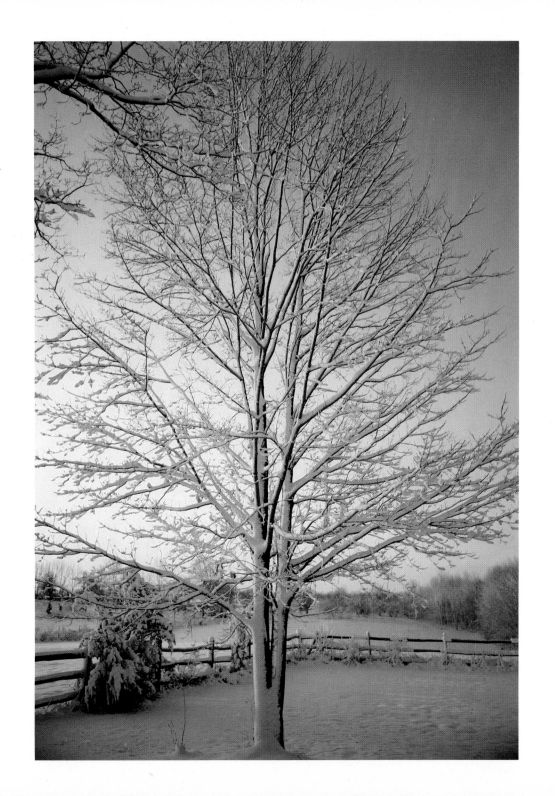